FIELDS OF VISION

The Photographs of John Vachon

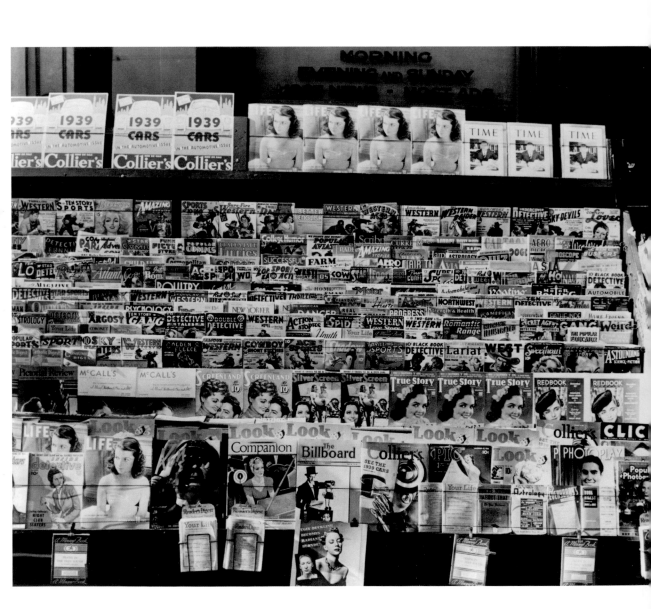

FIELDS OF VISION

The Photographs of John Vachon

Introduction by Kurt Andersen

g

THE LIBRARY OF CONGRESS, WASHINGTON, D.C.

Copyright © 2010 The Library of Congress
Introduction © 2010 Kurt Andersen
First published in 2010 by GILES
An imprint of D Giles Limited
4 Crescent Stables
139 Upper Richmond Road
London SW15 2TN
UK
www.gilesltd.com

For The Library of Congress:
Director of Publishing: W. Ralph Eubanks
Series Editor and Project Manager: Amy Pastan
Editor: Aimee Hess

For D Giles Limited:
Copyedited by Melissa Larner
Proofread by David Rose
Designed by Miscano, London
Produced by GILES, an imprint of D Giles Limited,
London
Printed and bound in China

**The Library of Congress is grateful for the support of
Furthermore: a program of the J.M. Kaplan Fund**

The Library of Congress, Washington, D.C., in
association with GILES, an imprint of D Giles Limited,
London

Library of Congress Cataloging-in-Publication Data
Vachon, John, 1914–1975.
The photographs of John Vachon /
introduction by Kurt Andersen.
p. cm. -- (Fields of vision)
"The Farm Security Administration-Office of War
Information (FSA-OWI) Collection at the
Library of Congress."
ISBN 978-1-904832-47-8 (alk. paper)
1. Documentary photography--United States.
2. United States--Social life and customs--1918–1945--
 Pictorial works.
3. Vachon, John, 1914–1975.
4. Library of Congress--Photograph collections.
I. Library of Congress.
II. United States. Farm Security Administration.
III. United States. Office of War Information.
IV. Title.
TR820.5.V32 2010
770.92--DC22
[B]
2009036413

Frontispiece: Newsstand, Omaha, Nebraska, November 1938.
Opposite: Daughters of a Tygart Valley homesteader, West Virginia, June 1939 (detail).
Page VI: Farm girl, Seward County, Nebraska, October 1938.
Page VIII: Cars parked diagonally along parking meters, Omaha, Nebraska, November 1938 (detail).

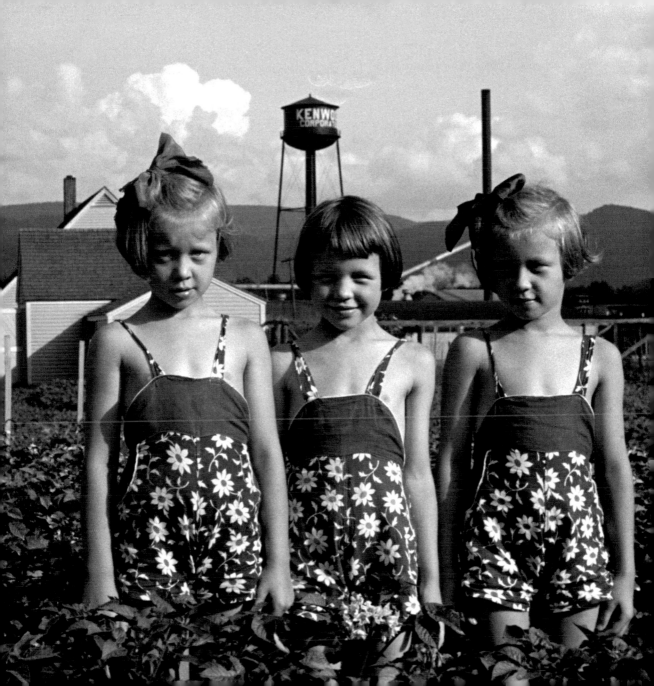

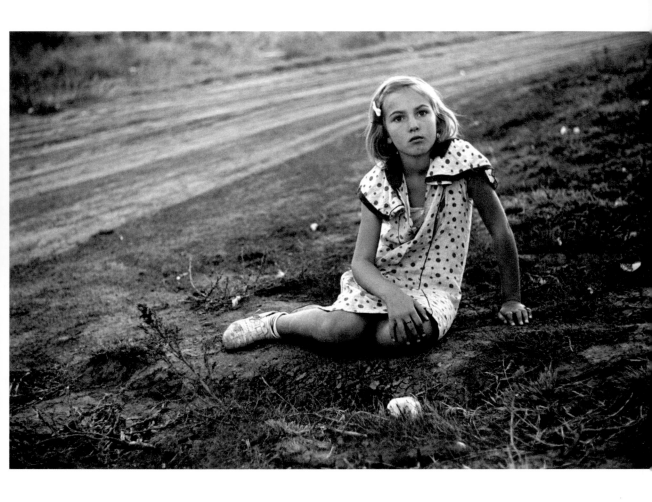

Fields of Vision
Preface

The Farm Security Administration–Office of War Information (FSA–OWI) Collection at the Library of Congress offers a detailed portrait of life in the United States from the years of the Great Depression through World War II. Documenting every region of the country, all classes of people, and focusing on the rhythms of daily life, from plowing fields to saying prayers, the approximately 171,000 black-and-white and 1,600 color images allow viewers to connect personally with the 1930s and 1940s. That's what great photographs do. They capture people and moments in time with an intimacy and grace that gently touches the imagination. Whether it is a fading snapshot or an artfully composed sepia print, a photograph can engage the mind and senses much like a lively conversation. You may study the clothes worn by the subject, examine a tangled facial expression, or ponder a landscape or building that no longer exists, except as captured by the photographer's lens long ago. Soon, even if you weren't at a barbeque in Pie Town, New Mexico, in the 1940s or picking cotton in rural Mississippi in the 1930s, you begin to sense what life there was like. You become part of the experience.

This is the goal of *Fields of Vision*. Each volume presents a portfolio of little-known images by some of America's greatest photographers—including Russell Lee, Ben Shahn, Marion Post Wolcott, John Vachon, Jack Delano, and Esther Bubley—allowing readers actively to engage with the extraordinary photographic work produced for the FSA–OWI. Many of the photographers featured did not see themselves as artists, yet their pictures have a visual and emotional impact that will touch you as deeply as any great masterwork. These iconic images of Depression-era America are very much a part of the canon of twentieth-century American photography. Writer James Agee declared that documentary work should capture "the cruel radiance of what is." He believed that inside each image there resided "a personal test, the hurdle of you, the would-be narrator, trying to ascertain what you truly believe is." The writers of the texts for *Fields of Vision* contemplate the "cruel radiance" that lives in each of the images. They also delve into the reasons why the men and women who worked for the FSA–OWI were able to apply their skills so effectively, creating bodies of work that seem to gain significance with time.

The fifty images presented here are just a brief road map to the riches of the Farm Security Administration Collection. If you like what you see, you will find more to contemplate at our website, www.loc.gov. The FSA OWI collection is a public archive. These photographs were created by government photographers for a federally funded program. Yet, they outlived the agency they served and exceeded its mission. Evoking the heartbreak of a family who lost its home in the Dust Bowl or the humiliation of segregation in the South, they transcend the ordinary—and that is true art.

W. Ralph Eubanks
Director of Publishing
Library of Congress

John Vachon

By Kurt Andersen

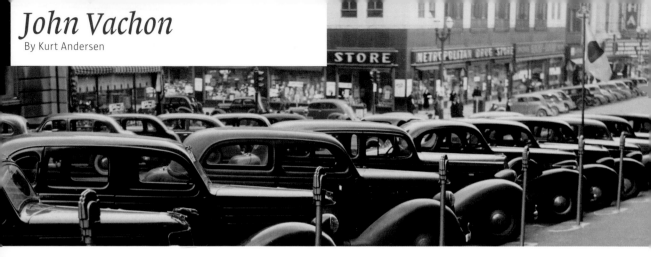

During the last few decades it has become commonplace to think of the federal government as inherently wasteful, not just incompetently managing essential programs but lavishing money on unnecessary and even harebrained projects. But looking back at the twentieth century, I see a heartening alternative history of federal funding for the inessential, especially when those projects have been *explicitly* quixotic and undertaken during periods of profound national anxiety. It was our sense of terrified competition with the Soviet Union, after all, that propelled the space program during the 1950s and 1960s, and which prompted the Department of Defense to underwrite the development of a global computer network during the 1960s and 1970s. The unintended byproducts of those zillion-dollar Cold War projects—from smoke detectors and computer-game joysticks to email and the Internet—are at once dazzling and useful.

Similarly, in response to the nightmare of the Great Depression came the sprawling New Deal bureaucracy, and from one of its tiniest, most inessential nodes—the Historical Section of the Information Division of the Resettlement Administration and its successor agency, the Farm Security Administration (FSA)—emerged an improbable marvel. Although it was a government agency created to document loans to farmers, the FSA almost immediately expanded its mission. The FSA

photographs produced between 1935 and 1943 make up a singular and enduring chronicle of American life at the beginning of the American Century, and they also established a new visual aesthetic, a clear-eyed, Walt Whitmanesque way of seeing the everyday that has influenced photography and filmmaking ever since. The work of the FSA photographers forms an invaluable archive of documentary art, a vast haystack containing hundreds of breathtakingly beautiful needles.

In the late 1930s, a very earnest memo written by a very young FSA clerk perfectly articulated the project's mission statement. "[W]e are today making a conscious effort to preserve in permanent media the fact and appearance of the 20th century" and to "leave for the future a very living document of our age, of what people today look like, of what they do and build." That clerk was John Vachon, a graduate-school dropout who had been hired at age twenty-one by Roy Stryker, the founding director of the Historical Section. Vachon's initial job was captioning the pictures that the FSA's roving team of photographers—Walker Evans, Dorothea Lange, Carl Mydans, Arthur Rothstein, Ben Shahn—sent from the field back to Washington. Soon, he was in charge of the whole file, which grew by an average of 400 photographs a week over the life of the program.

But Vachon, a lover of contemporary literature (especially Thomas Wolfe), music (from Stravinsky to Louis Armstrong), movies, and painting, burned with artistic ambition, and Stryker, a manifestly superb manager of creative talent, gave him the go-ahead in the spring of 1937 to borrow a camera and start taking pictures around Washington, D.C. First, he used a cheap Agfa, and then Shahn instructed him in the basics of the Leica, the Model T of compact 35-millimeter cameras, while Evans insisted that he also learn to use a big old-fashioned view camera, producing one 8 x 10 image at a time. By summer, Vachon was out shooting every weekend.

Given that he was more familiar with the FSA trove than anyone else on earth, it's no wonder that some of Vachon's first photographs are imitative. In one of his earliest Washington pictures a tattily dressed man walks past a poster of a worker (labeled "LABOR") shaking hands with a businessman ("CAPITAL") beneath the word "PROSPERITY" (24). It's an ironic image of an image—a new photographic trope freshly established, when Vachon took his picture, in two of the best-known FSA pictures: Walker Evans' shot of a glamorous Carole Lombard movie poster in front of run-down Atlanta houses, and Dorothea Lange's photograph of a pair of men walking past an upbeat Southern Pacific billboard ("NEXT TIME TRY THE TRAIN ... RELAX") on a California highway.

This is not meant to diminish the quality or originality of Vachon's work. His finest pictures are among the most compelling produced by the FSA. And indeed, because he was not one of the superstars, such as Evans and Lange, whose best-known pictures overwhelmingly define Americans' sense of the Great Depression, it's the very *unfamiliarity* of Vachon's photographs that make them so revelatory today. They provide us with entirely fresh, bracing glimpses into the late 1930s and early 1940s—" a very living document of our age"—that the supremely familiar, iconic images cannot. It's like amps and volts: the greatest FSA images all have an equivalent visual amperage, but the best work of the uncelebrated photographers, such as Vachon, was never piped into public consciousness at high voltage, and so, seeing them properly presented for the first time in the twenty-first century comes as a thrilling shock.

Moreover, the ultra-familiar FSA photographs became almost *instantly* well known, shaping people's sense of the Depression during the Depression. America had never had this real-time experience of looking at itself in a mirror. The new compact cameras meant that many more images were being produced than ever before, and the new, photo-driven mass media meant that millions more people were seeing those images. The weekly magazine *Life* was launched in November 1936, and its rival, *Look*, appeared three months later. Both magazines published FSA photographs, as did hundreds of daily newspapers. It was the Big Bang moment for the modern news media, one that radically intensified the influence of photographers' work on fellow photographers as well as on the culture at large. Lange's portrait of an impoverished migrant pea-picker and two of her children was already an iconic image when Vachon took up photography, and before the end of 1937 Margaret Bourke-White had published her bestselling collection of sharecropper portraits, *You Have Seen Their Faces*. In 1938, the Museum of Modern Art mounted a show of eighty-seven of Evans' pictures.

We think of the late twentieth and early twenty-first centuries as being uniquely media-saturated, of ourselves as unavoidably experiencing life in reference to pre-existing images. In this sense Vachon was among the first modern, fully and self-consciously media-responsive American image-makers. "I went around looking for Walker Evans' pictures," he said in an interview in 1973. "I remember once in Atlanta where I knew so well a certain house he had photographed, I would walk all over town looking for it, and when I'd find the real thing, you know, maybe three or four years after he had ... and when I'd see the honest-to-God Walker Evans in reality, it was like a historic find." Even after Vachon had developed his own sensibility and credentials, he was matter-of-fact about his inescapably mediated vision of America's vernacular nooks and crannies. In a 1940 letter to Stryker from Dubuque, Iowa, he reported that there were "4 Walker Evans type R.R. stations in town." And in a 1942 letter to his wife Penny from Oklahoma, he told her he was seeing "real grapes of wrath stuff," referring to the 1939 John Steinbeck novel and/or 1940 John Ford

movie. (These and the other letters and journal entries from which I quote are contained in Miles Orvell's wonderful *John Vachon's America*, published in 2003 by the University of California Press.)

The point is, when the young Vachon took up documentary photography in 1937, photographic images of a heretofore unseen America—timely, artful, galvanizing—were suddenly ubiquitous and celebrated. The surprise in looking at Vachon's work seventy years later is not that a few of his early pictures mimic those of his heroes and mentors, but that as an apprentice in his twenties he was able to forge and pursue his own vision so determinedly and successfully.

Vachon is an FSA outlier in several respects. Stryker didn't make him an official photographer until late 1940 or early 1941, yet he took half of the pictures presented here before then. Eight of these fifty-two images are in color, even though color pictures make up less than 1 percent of all the FSA photographers' work. Again, the unfamiliarity comes as a refreshing gift: rich color images of an era that we have mentally registered as black-and-white force us to think of the period anew, allow us to see the past as not quite such a foreign country where they do things differently. Although all of the color images in this book are from 1942 and 1943, the final years of the FSA photography project, Kodachrome film had been available since 1935, and Vachon was experimenting with it as early as 1938, during what he called his first "really good, long assignment," his "plum": a month-long expedition to Nebraska.

When it was proposed that I write this introduction, I was intrigued by the basics of Vachon's story and the few photographs I'd seen. But when I learned of his Nebraska trip, I was hooked, a thrilled victim of serendipity. I was born in Omaha sixteen years after Vachon's visit, and grew up there, so I recognize neighborhoods and blocks and buildings in his pictures. And my late parents were both lifelong Nebraskans. During what Vachon called his "cold November week in Omaha," wandering and shooting—"I walked a hundred miles," he said—he must have repeatedly passed by the city's great downtown landmark, Central High School, inside which my mother was at that moment a member of the junior class. When Vachon traveled across

Nebraska in his Union Pacific train, the engineer would have blasted the locomotive's horn as he passed through the little town of Valley, twenty-five miles west of Omaha, and my father—Valley High School class of 1939, aged seventeen—would have heard it.

When Vachon first crossed the Missouri River into Nebraska, he was, however, unimpressed by the view out the train car window. "I was awake as we went through Omaha," he wrote to Penny. "[I]t looks so damned unspectacular, ordinary. It looks like it will be tough to photograph." He continued 300 miles west, finally stopping in mid-October at North Platte. North Platte had a population of only 12,000, but it was a Great Plains vice capital known as "Little Chicago." In a letter to Stryker, his boss, Vachon called it "a swell town. I'd liked to have stayed in there a few weeks. It was the first and only Nebraska town I've been in that sold liquor over the bar."

Vachon liked his liquor: getting drunk had cost him his graduate-school scholarship at Catholic University in 1936, and one of his admiring editors at *Look* magazine in the 1950s recalled him as a "hard-drinking man." On the night of October 28, 1938, he walked into North Platte's Alamo Bar, which he described to Penny in a letter the following day as "a saloon in the grand tradition" and where, he told her, he got "pretty plastered" on "great gobs of [beer] ... in the line of duty ... At the piano was a big huge large fat blonde woman of 45 to 50 yrs. With beautiful smeary red makeup on her puss." According to a letter to Stryker, the piano player was "an ex-Omaha prostitute, and very proud of it" and played "only very nasty songs. So I told her I was a Broadway scout and would like to take her picture. Of course she thought it was a swell idea."

The result is "Mildred Irwin, entertainer in a saloon in North Platte" (9). The flashbulb brightness on energetic, bemused Mildred in the foreground makes her the star, but it's the background figures—those two dour, possibly sinister men on barstools—who give the picture its dark, redolent narrative oomph. It's an almost grotesque image reminiscent of the photographer Weegee, but to my eye sweeter, less cynical, more complex. Vachon, in this image and others, depicts a version of Depression life that appears rarely in the more earnest,

unsmiling work of his FSA colleagues: the honky-tonk chanteuse, the musical couple and dancing teenagers (25, 26), and the farm boys eating ice cream (6) may be victims of circumstance, but they're eking out pleasures where they can.

A picture from the same week, reproduced here facing the Preface, shows Vachon's extraordinary range of sensibility and documentary intent. Two days before he shot the noirish North Platte saloon scene, he stopped on a dirt road in the middle of nowhere to photograph a pretty ten-year-old girl sitting on the ground near her parents' farm, which had no running water or electricity. Vachon could see with the gimlet eyes of James M. Cain (*The Postman Always Rings Twice*, *Double Indemnity*), but could, with equal conviction, enter an elegiac Willa Cather frontier. His picture of the ex-whore has the intricate bawdiness of a Reginald Marsh drawing; his portrait of Claudine Abele, the Seward County farm girl sitting with her legs folded under her, prefigures Andrew Wyeth's spare, poignant *Christina's World*, painted ten years later.

After three weeks in Nebraska, Vachon was thrilled. "I'm feeling awfully good about everything I've done so far on this trip," he wrote to his wife. "I think I have a big batch of 1st rate stuff, and I feel myself getting better all the time—more confident, better able to handle people, and having better ideas pop more often." When he finally got to Omaha—population 220,000, a place not unlike St. Paul, Minnesota, where he'd spent his first twenty years—he wrote to Penny that "[t]his city looked much more inviting to the photographer in me as I entered it this afternoon. [T]here was a nice light, and I saw dozens of things I would like to get."

In Nebraska he started to shrug off his anxiety of influence. "I'd say that week in Omaha," Vachon said two years before he died:

> was my first completely free photographic job, where I just walked around the city, stockyards, and the slums, and so on. One morning I photographed a grain elevator: pure sun-brushed silo columns of cement rising from behind a CB&Q [Chicago Burlington and Quincy] freight car. The genius of Walker Evans and Charles Sheeler welded into

one supreme photographic statement, I told myself. Then it occurred to me that it was I who was looking at the grain elevator. For the past year I had been sedulously aping the masters. And in Omaha I realized that I had developed my own style with the camera. I knew that I would photograph only what pleased me or astonished my eye, and only in the way I saw it.

Walker Evans and Dorothea Lange had already made the Deep South and rural California theirs; Vachon in his FSA years mostly stuck to the Great Plains—west of the Mississippi River and east of the Rocky Mountains—and the northeast. And unlike most of his FSA peers, many of his pictures are distinctly urban, not just the pictures from Washington, D.C., and Omaha, but shots of New York City (8), Chicago (27), and Cincinnati (36). On the other hand, when he was shooting in the Plains, he seemed to seek out the most isolated boondocks of a boondocks region, chronicling life in essentially secret towns such as Borger, Texas (22), Sisseton, South Dakota (46), and Wisdom, Montana (41, 42).

Vachon was both a reliable middle-class professional and a bohemian vagabond. At age twenty-one, he wrote in his journal, "I can always become a damn no account begging, bumming, traveling hobo, if ever I get the moral courage to become such." The next day he got his steady government job. And yet again, when he embarked on that month-long journey to Nebraska, he left behind his brand new wife and newborn daughter. For the next five years, just before Woody Guthrie recorded *This Land Is Your Land* and Jack Kerouac (another Thomas Wolfe devotee) set out on the road, Vachon wandered around America, looking and shooting. "My deepest and strongest and fondest memories," he said in his 1973 interview:

> are all connected with traveling around this country, seeing places that I'd never been before. I had traveled very little until that time, I'd only been from my native Minnesota to non native Washington, and it was just great to be alone in a car and to be paid for driving around and taking pictures of what you liked to take pictures of ... [I]t was just a case of every morning looking at the road map ... I would drive to a town because I liked the sound

of the name. There was a place in North Dakota called Starkweather, and it seemed that there should be some great pictures there so I went there.

A will-o'-the-wisp, but his record-keeping was scrupulous, if not extreme: for his whole life he noted every train he took, the name of every county in which he set foot, the aggregate number of hours he spent in each state.

Vachon was a worshipful apprentice, desperate to forget the templates of his heroes' images, a super-conscientious bureaucrat as well as a boozy rambling man, eager to shoot both big cities and tiny specks on the map (but seldom large towns and small cities). Again and again he photographed panoramic landscapes of North Dakota and Montana bleakness that overwhelm the heroic and bathetic signs of human settlement. Almost half the images in this book include no people. But he also made penetrating, humane, intriguing portraits of very particular individuals. In addition to Mildred Irwin and Claudine Abele in Nebraska, I return again and again to stare and wonder at the lives of the Washington, D.C. "Proprietor of a tombstone shop" (10), who looks to me like an unfunny brother of the satirists H.L. Mencken or George S. Kaufman; the three identically dressed "Daughters of a Tygart Valley homesteader" (14) in a field of their newly built New Deal community in West Virginia; the bow-tied "Town policeman, Litchfield, Minnesota" (50), who could pass for a supporting player in It's A Wonderful Life, the startlingly blank masonry behind him a wall on an RKO back lot.

The New Deal and World War II were for America a historical pivot point between the old days and the modern age, and Vachon vividly captures the gradations of this cusp. Today, Houston is the ultimate shiny new car-clogged metropolis, but in Vachon's Houston, a Miss Havisham-ish house (note the grand conical cupola atop ... nothing) is fronted by a fruit stand and horse-drawn wagon (38), and in a small Texas town a virtually nineteenth-century "Man going to the livestock auction" (7) rides his horse through automobile traffic. And then there are the strange, riveting images of the emerging military-industrial complex, the surreal shape of things to come: a "soldier in a decontamination outfit" (21), "Storage tanks at Phillips gasoline plant" (22), and a "Worker at a carbon black plant" in the brand new middle-of-nowhere Texas panhandle town of Sunray (49).

Vachon was a dutiful documentarian, but it's his formalist aesthetic bent that distinguishes his pictures. Consider, for instance, the four Omaha photographs in this book. All are highly graphic, revealing the presence of both self-conscious and accidental design in everyday Middle America. There's the iconically majestic agro-industrial shot (20) depicting sun-brushed silo columns of cement rising from behind a Chicago Great Western freight car. The three others, smaller-scaled and more specific—a row of diagonally parked cars and parking meters (47), an extravagantly decorative rooming house window (19), a newsstand, facing the title page (then as now, a frenzy of celebrity magazines with Time and The New Yorker poking through)—celebrate a kind of urbane pizazz atypical of FSA pictures. Vachon also photographed Omaha's hobos and beggars and slum housing, but he responded with open-eyed curiosity to what he happened to see—the sleek as well as the homely—rather than sticking to any strict sociopolitical agenda. His best pictures are never standard-issue or over-determined, demanding of us a particular pitying or heart-stirring response. They suggest instead ambiguous lives and stories in a wide variety of emotional flavors.

At a historical moment when a Manichean view of the world was understandable—misery was rampant and evil on the march—Vachon maintained his acutely ambivalent point of view. He was a good 1930s liberal with The Communist Manifesto and works by the left-wing writer James T. Farrell on his reading list. He photographed "evicted sharecroppers" in Arkansas (13), a "migrant fruit worker" in Michigan (3), striking office workers in Chicago (27), as well as a blind beggar outside a Washington bank (28) and a Jim Crow water fountain at a North Carolina courthouse (15). None of his pictures, however, wallow in pathos. Vachon was not by nature an ideologue.

In 1939, Vachon and his family moved out of D.C. to suburban Greenbelt, Maryland, a New Deal cooperative community, but Vachon didn't quite sign on to the utopian dream. "And a home," he wrote sardonically in his journal, "a ducky little

white apartment of a home in a model community … among thousands of model dwellers in a model community." Three years later, once again in Nebraska, he wrote to Penny that while he had been put off by a smug proto-yuppie couple he'd met (and photographed), on the other hand, "I hate preachers, proselytizers, ax grinders too. I don't want my people to be social reforming all over the place, or anything like that." His most interesting "political" pictures are the subtlest ones, such as the (bored? peevish? skeptical?) black men hanging around in front of the Washington house in which Abraham Lincoln died, now a tourist attraction (16), and the Beaumont, Texas, shipyard workers at the end of their shift—six queues of men, five all white and one all black (35).

During its last year, the FSA photography project was absorbed by the Office of War Information (OWI), and its mission changed. "We photographed shipyards, steel mills, aircraft plants, oil refineries," Vachon recalled later, "and always the happy American worker. The pictures began to look like those from the Soviet Union." The unit closed in 1943. Vachon worked several years more for Stryker, who had convinced Standard Oil of New Jersey to fund a kind of private-sector FSA photography project. In 1947 he started shooting for *Look*, where he remained for the rest of his career. His wife Penny struggled with depression and committed suicide in 1959; Vachon, already the father of three, remarried in the early 1960s and had two more children. In 1975, four years after *Look* stopped publishing, John Vachon died of cancer. He was sixty.

Why are the other great Depression photographers so much better-known? Partly it was a matter of timing. Almost all the others—Evans, Lange, Bourke-White, Carl Mydans—were a decade or two older, and his FSA colleagues had started shooting in 1935, two crucial golden years before Vachon picked up a camera. Then there was his personality. He did not brim with confidence. In a 1939 journal entry he refers to his "job as a semi-photographer, a picture clerk, a photographic flunky, a clod of government clerk, a hangnail on the great toe of Uncle Sam," and two years later he was still beating himself up: "I have never done any really good, or even above average work. Nothing with

sincerity, or incisiveness, or deep conviction." Not surprisingly, he lacked any natural flair for self-promotion. In a 1942 letter to Penny, he refers to "my old trouble, my inability to talk well, or at least the way I want to. My non-Dale-Carnegie-ity." Thomas Morgan, his colleague at *Look*, remembered him as "a quiet man, shy to the point of disability." Walker Evans went to Alabama with his up-and-coming Time Inc. colleague James Agee, out of which came *Let Us Now Praise Famous Men*; Dorothea Lange worked with (and married) the well-known Berkeley economist Paul Taylor, with whom she published *American Exodus*; Margaret Bourke-White produced *You Have Seen Their Faces* with (and then married) the famous novelist Erskine Caldwell. Vachon worked alone, and never published a book.

And while he may have been a chronically dispirited loner, perhaps another reason why he didn't acquire a big reputation is because his Depression pictures were insufficiently depressing. Their eclecticism didn't conform to any simple, canonical Depression script. And after the war, when so much of the most fashionable American documentary photography devolved to a kind of contemptuous suspicion of its subjects, Vachon was again out of luck. His intense ambivalence helped him produce good, complex pictures, but it didn't make for an easily digested, reputation-nurturing story. "I am indeed in an envied position," he wrote in 1954 of his apparently glamorous Manhattan life and career as a photojournalist. "And though I say, truthfully, that I reject this civilization … I nevertheless rejoice in it, and pander to it."

The greatness of Vachon's portrait of America is that it's not a happy-all-the-time Bedford Falls nor a ghastly Pottersville, neither propagandistically pro- nor anti-American, but achieves some truer, more complicated, liminal version of the nation at midcentury. In his 1937 memo to Stryker, before he'd plunged out into the continent with his cameras, he'd formed his double-edged view: "To photograph the American highway, the cameraman must know it, and have an attitude. A definite feeling about it. He may see it as a gay, bright colored regalia, the folk art of America, the carnival of America's people; or he may see it as a sorry manifestation of a decayed culture, a greedy civilization destroying America's natural beauty." Or he may see it as both.

1

Landscape, Northeast Utah, April 1942.

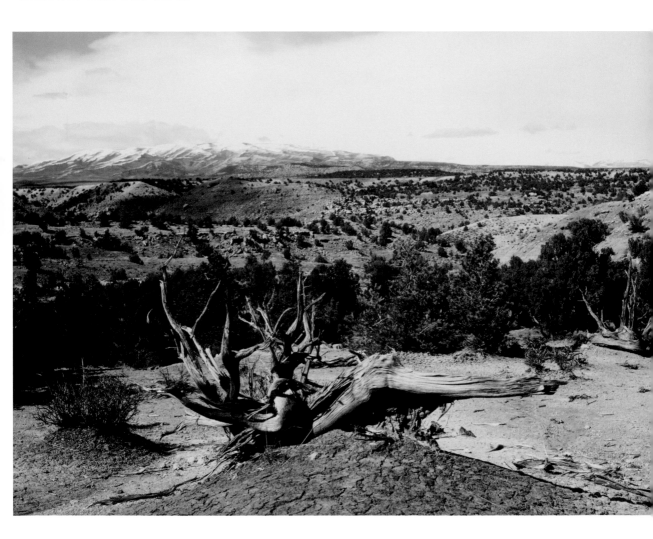

2

Sheep ranch of Charles McKenzie, Garfield County, Montana, March 1942.

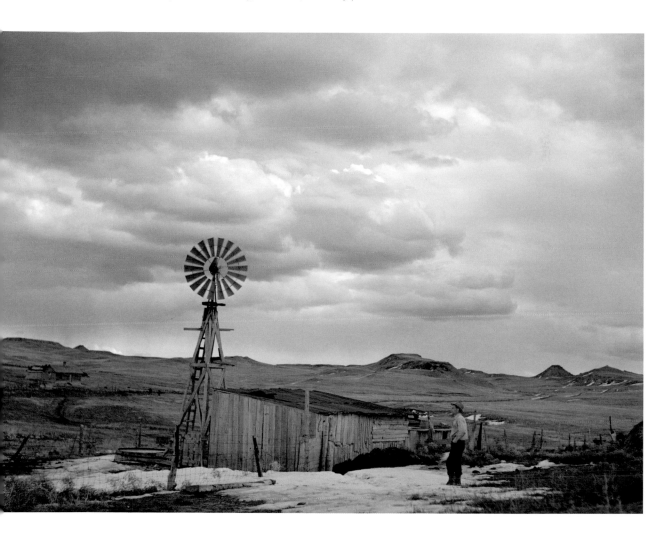

3

Migrant fruit worker from Arkansas, photograph taken in Berrien County, Michigan, July 1940.

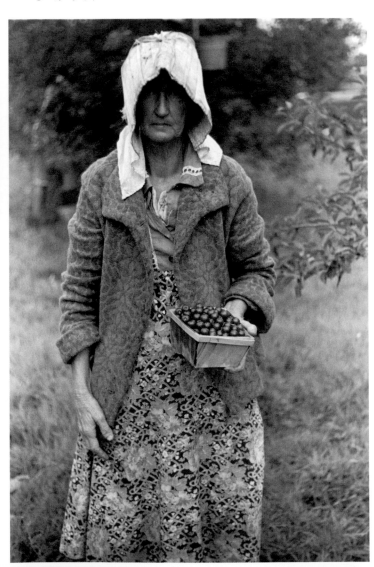

Automobile of migrant cherry pickers, Berrien County, Michigan, July 1940.

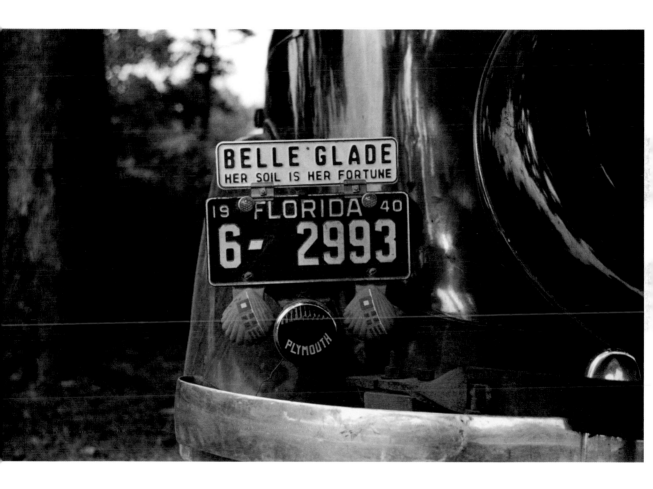

5

Women in front of the bank, San Augustine, Texas, April 1943.

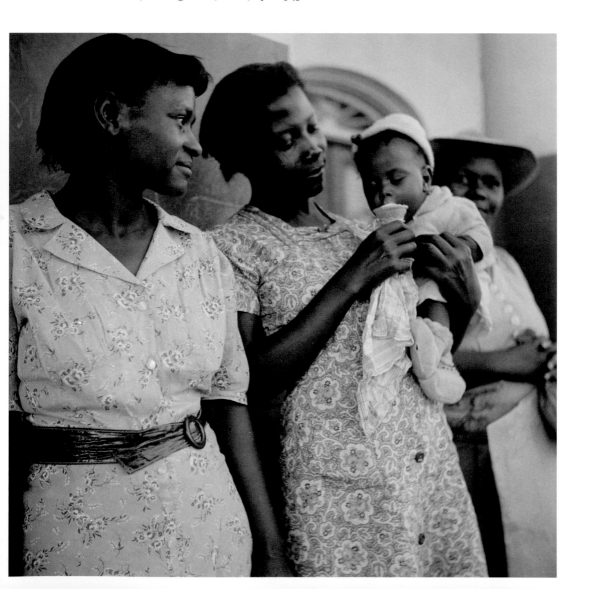

6

Farm boys eating ice-cream cones, Washington, Indiana, July 1941.

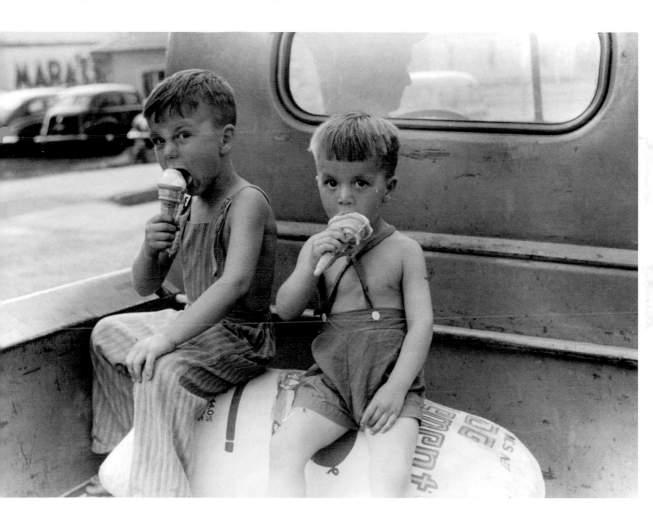

A man going to the livestock auction, San Augustine, Texas, April 1943.

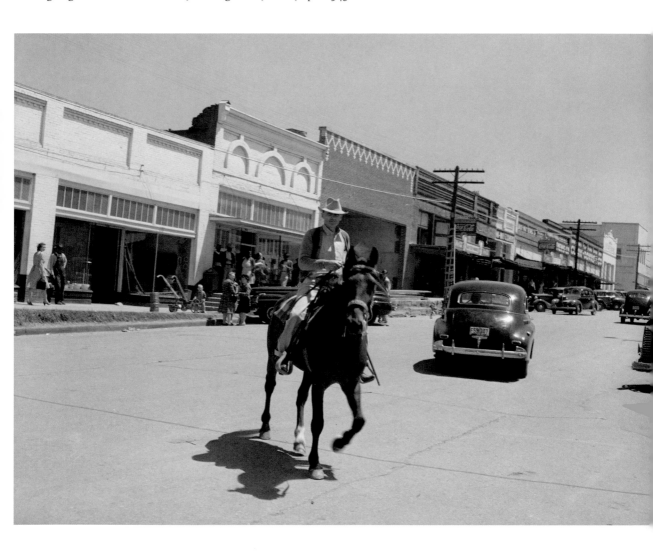

Camel cigarette advertisement in Times Square, New York, New York, February 1943.

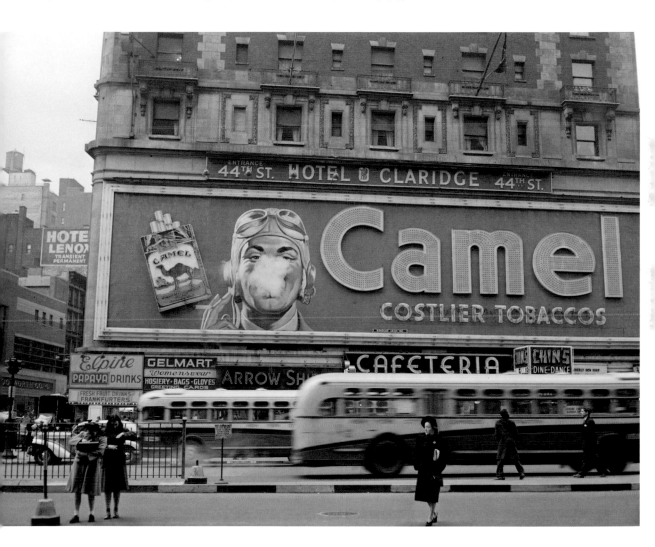

9

Mildred Irwin, entertainer in a saloon in North Platte, Nebraska, October 1938.

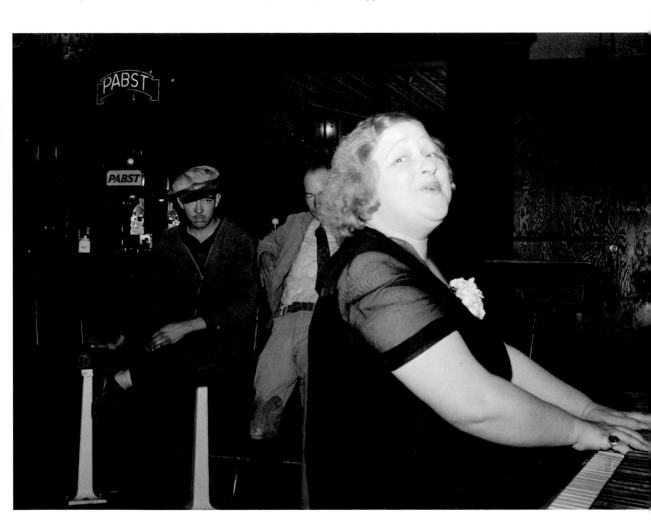

Proprietor of a tombstone shop, Washington, D.C., November 1937.

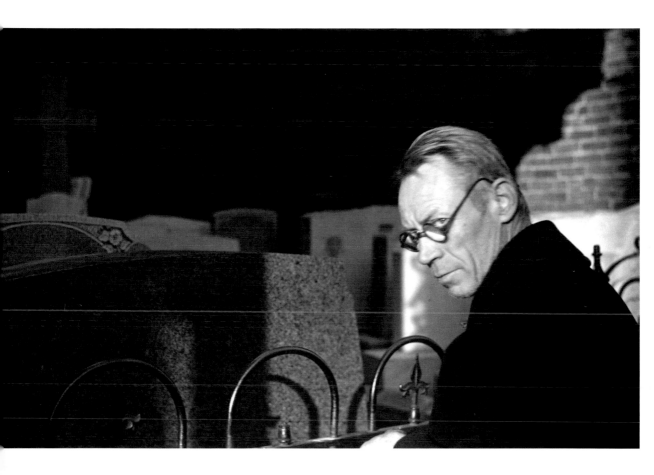

11

Company coal town, Kempton, West Virginia, May 1939.

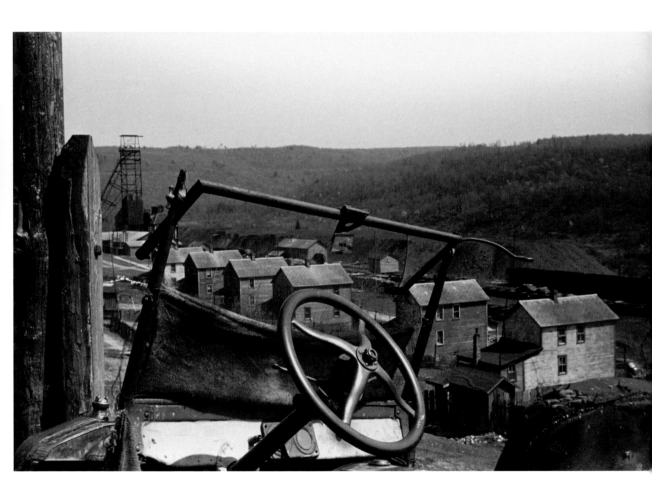

Boy hopping a freight train, Dubuque, Iowa, April 1940.

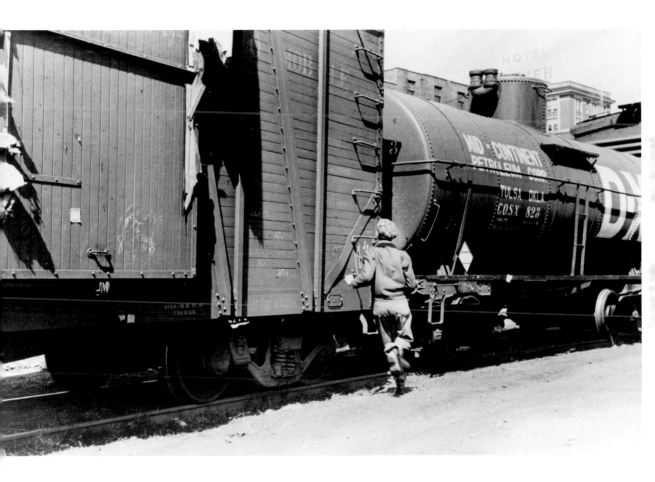

13

The families of evicted sharecroppers of the Dibble plantation before moving into a tent colony, the vicinity of Parkin, Arkansas, c. January 1936.

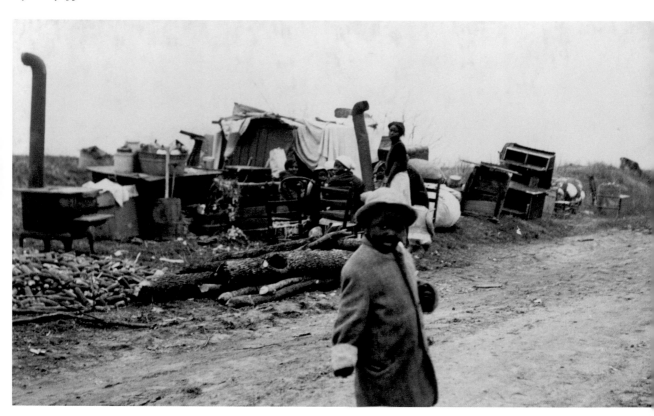

Daughters of a Tygart Valley homesteader, West Virginia, June 1939.

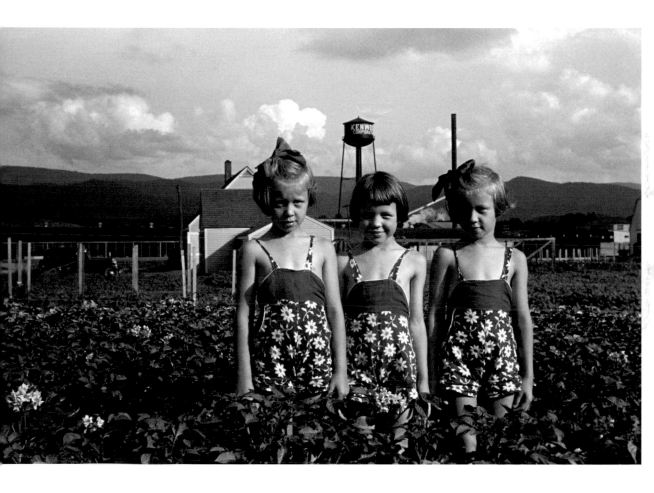

15

Drinking fountain on the county courthouse lawn, Halifax, North Carolina, April 1938.

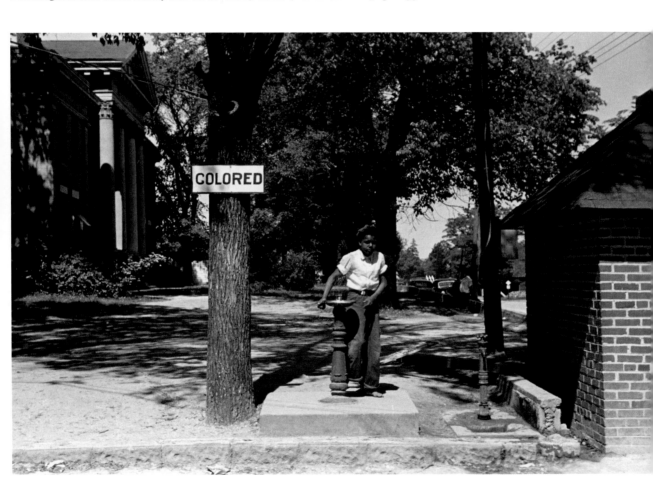

16

Men outside the house where Lincoln died, Washington, D.C., December 1937.

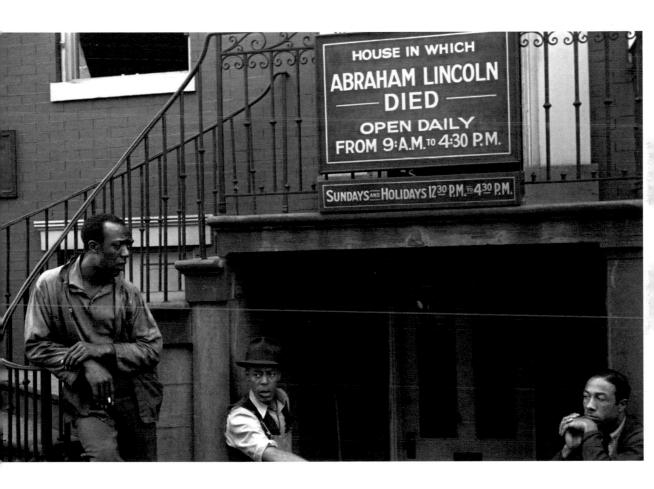

Rural schoolhouse where farmers have come to attend a Food for Victory meeting sponsored by the U.S. Department of Agriculture, Adams County, North Dakota, February 1942.

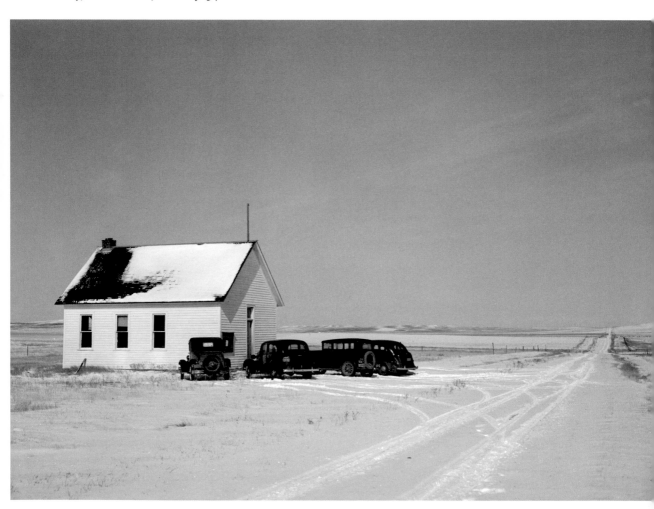

18

A tobacco farm, August 1941.

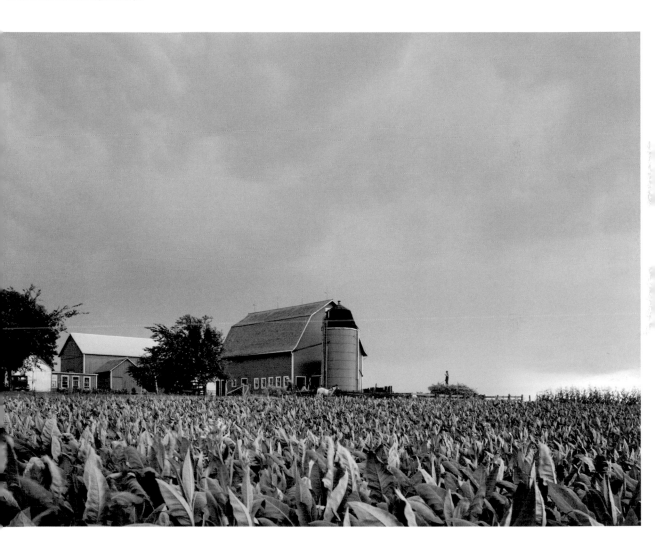

Window in a rooming house, Omaha, Nebraska, November 1938.

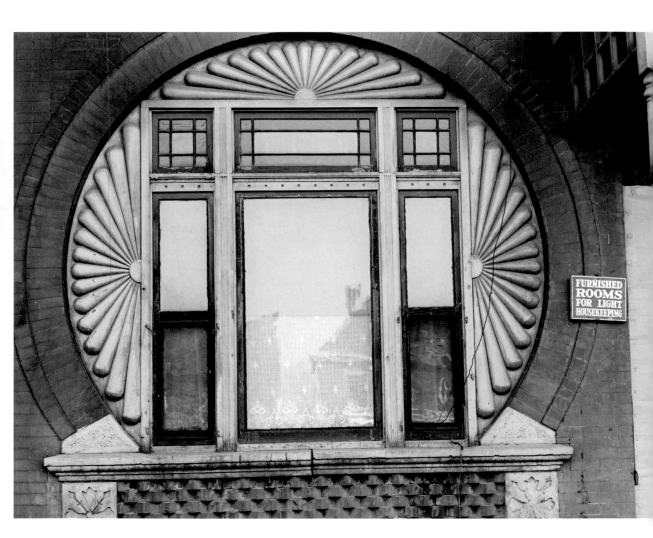

Freight car and grain elevators, Omaha, Nebraska, November 1938.

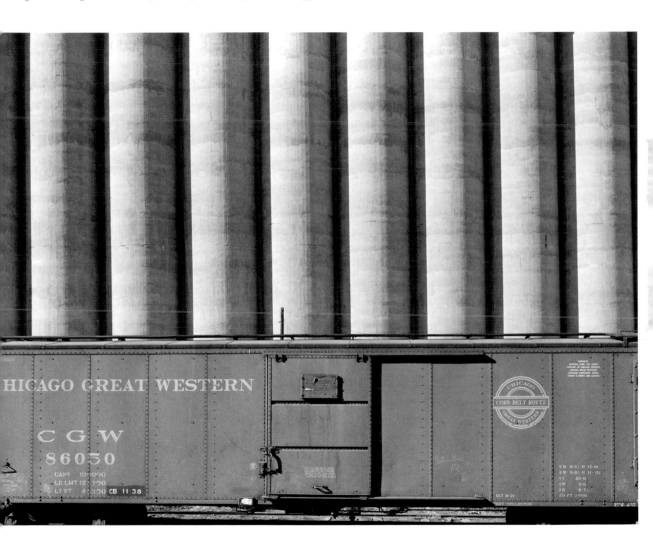

Constantine P. Lihas, a twenty-one year old Greek-American soldier, in a decontamination outfit, Fort Belvoir, Virginia, December 1942.

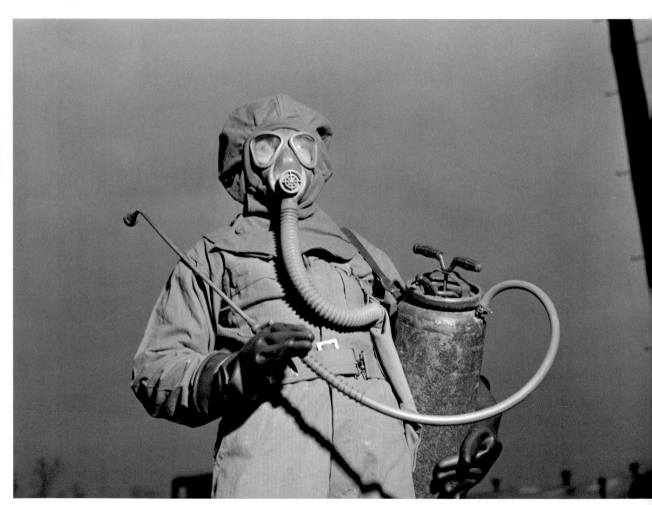

22

Storage tanks at Phillips gasoline plant, Borger, Texas, November 1942.

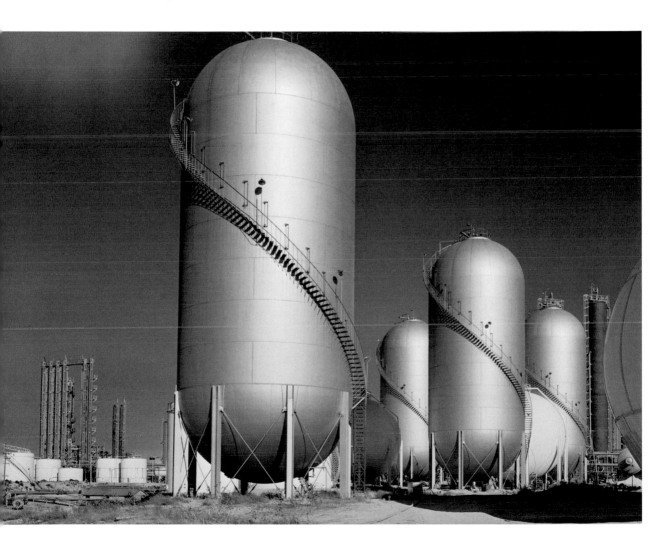

23

Window in the home of an unemployed steelworker, Ambridge, Pennsylvania, January 1941.

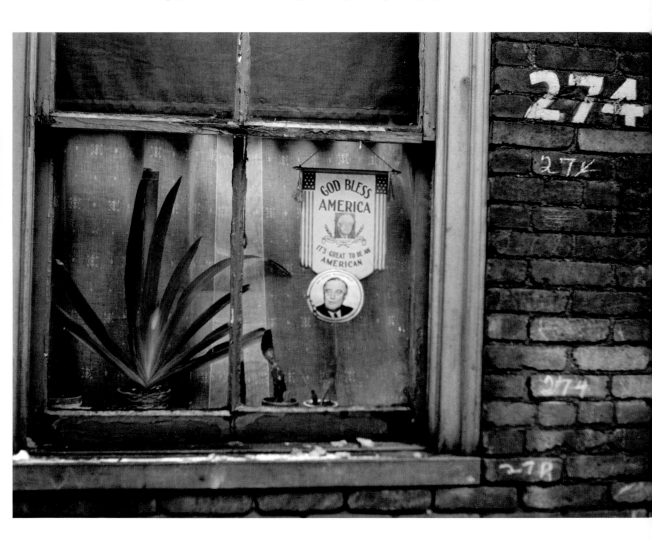

Street scene, Washington, D.C., April 1937.

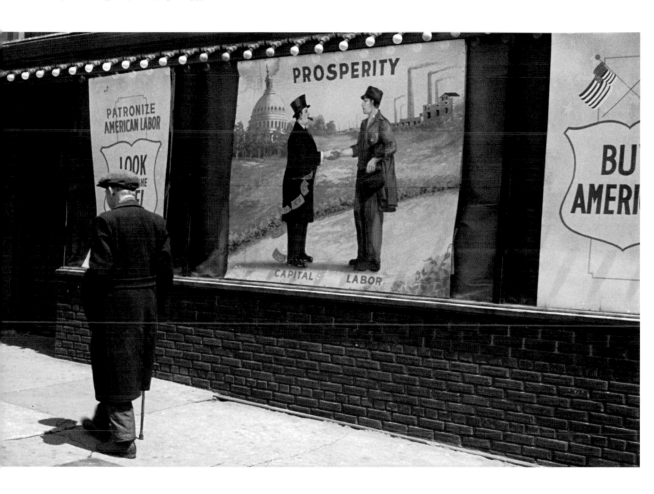

Mr. and Mrs. Dyson, Farm Security Administration borrowers, Saint Mary's County, Maryland, September 1940.

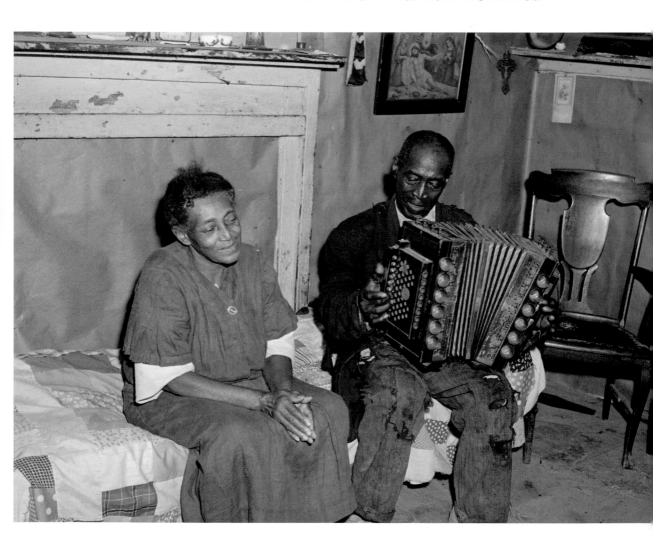

Farm boys and girls dancing to a jukebox at Mary's Place on U.S. Highway 29 near Charlottesville, Virginia, March 1943.

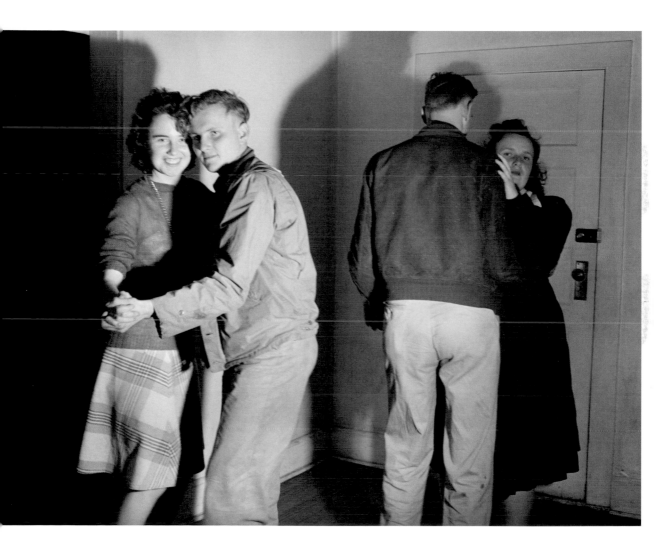

Picket line in front of Mid-City Realty Company, South Chicago, Illinois, July 1941.

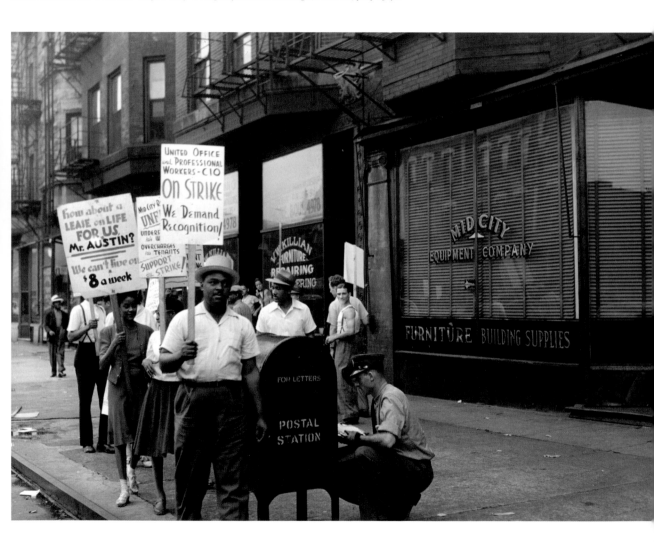

Blind beggar, Washington, D.C., November 1937.

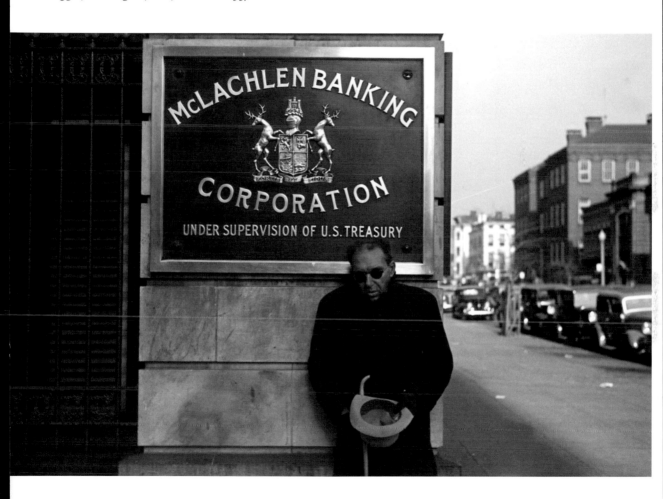

29

U.S. Highway 12, vicinity of Hettinger, North Dakota, February 1942.

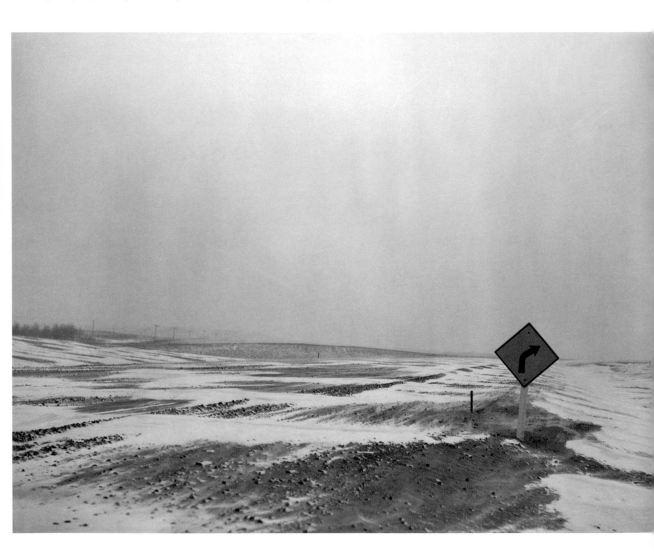

Landscape, McHenry County, North Dakota, October 1940.

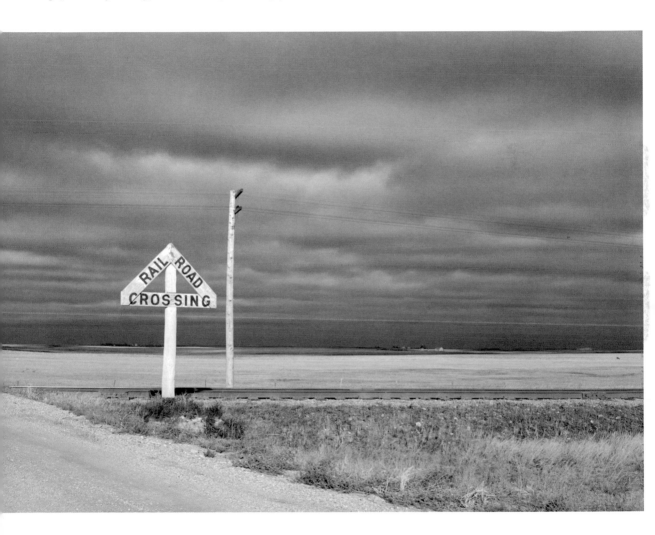

Street scene, Washington, D.C., November 1937.

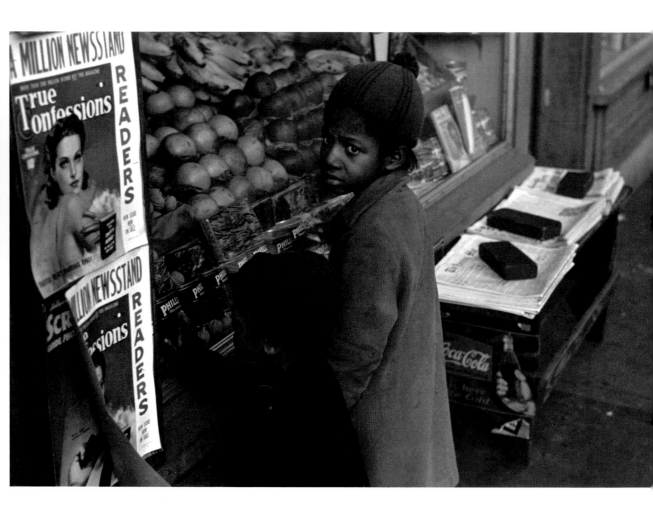

Man on the street, Washington, D.C., December 1937.

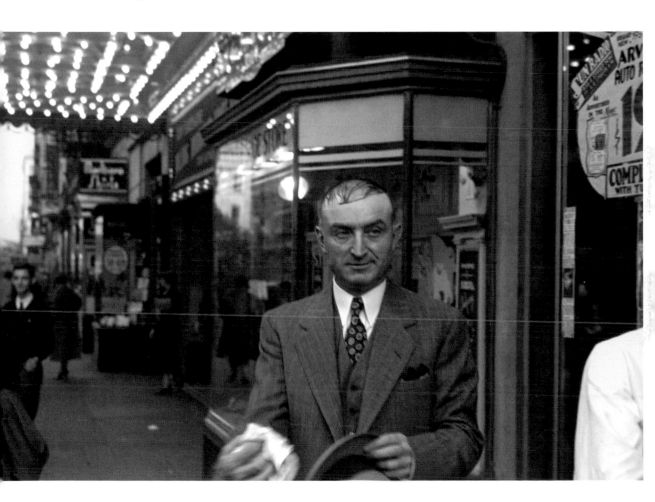

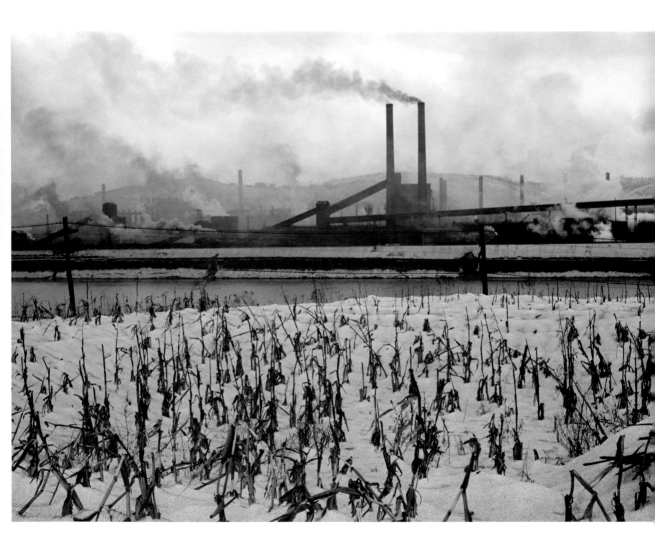

33

Jones and Laughlin Steel Company, Aliquippa, Pennsylvania, January 1941.

34

Church near Junction City, Kansas, 1942 or 1943.

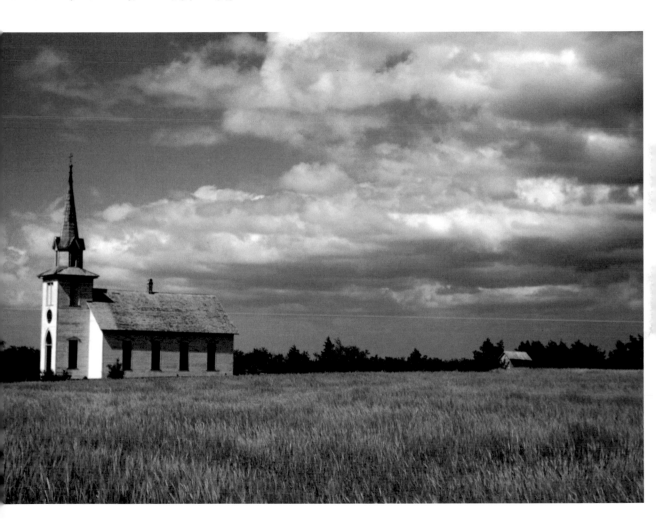

Workers leaving Pennsylvania shipyards, Beaumont, Texas, June 1943.

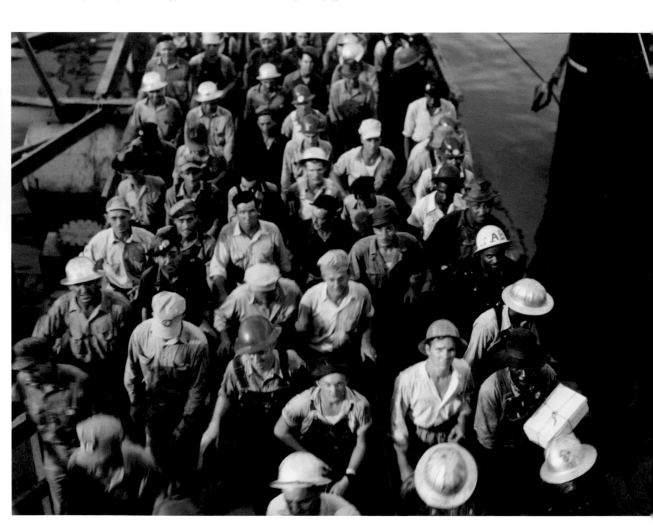

Spectators watching a parade go by, Cincinnati, Ohio, October 1938.

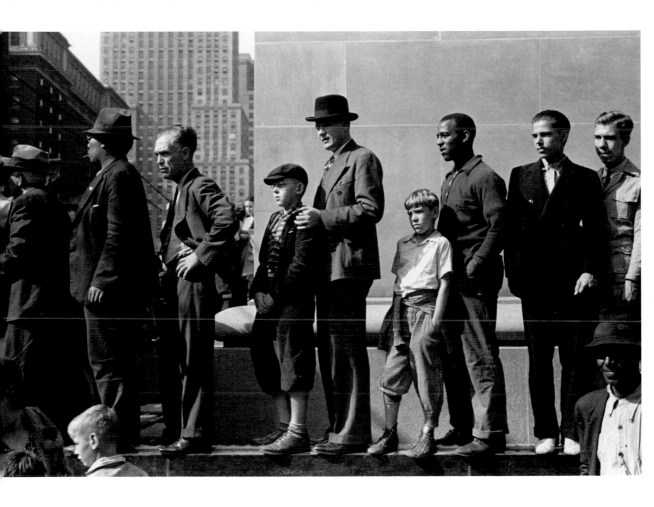

37

Junkyard, Washington, D.C., August 1938.

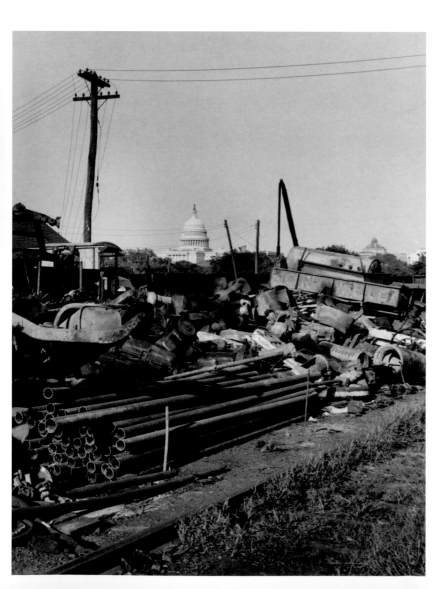

38

House, Houston, Texas, May 1943.

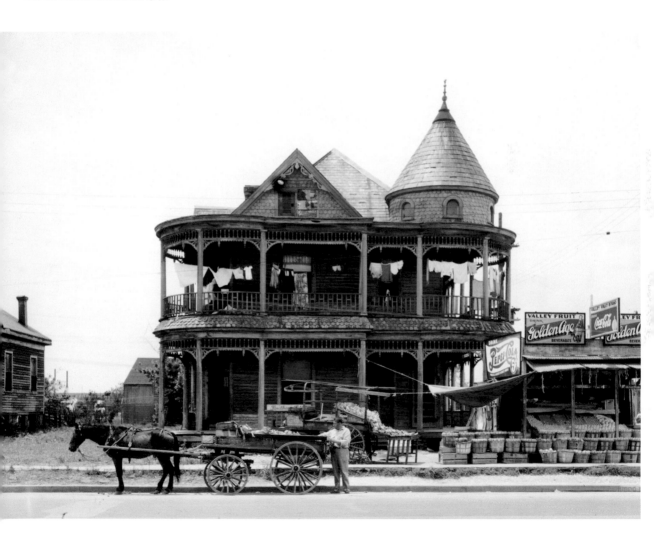

Young boy near Cincinnati, Ohio, 1942 or 1943.

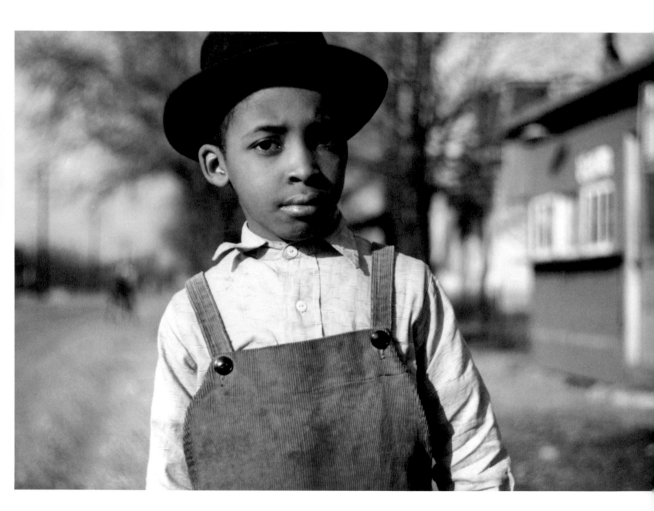

Rural school children, San Augustine County, Texas, April 1943.

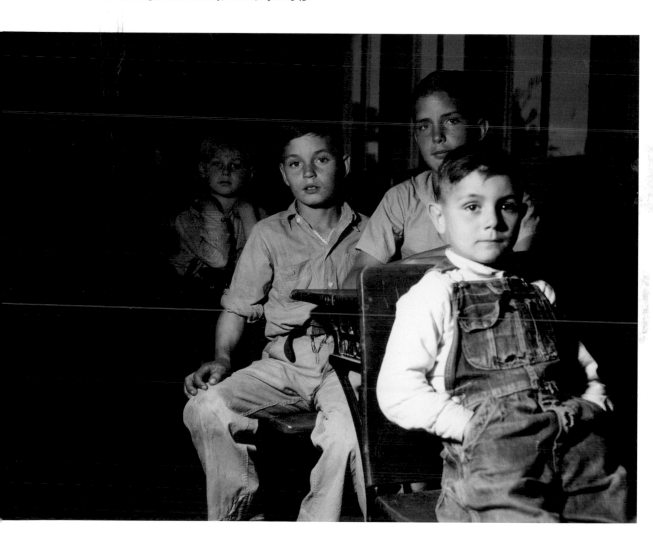

41

Singing hymns at Sunday school, Wisdom, Montana, April 1942.

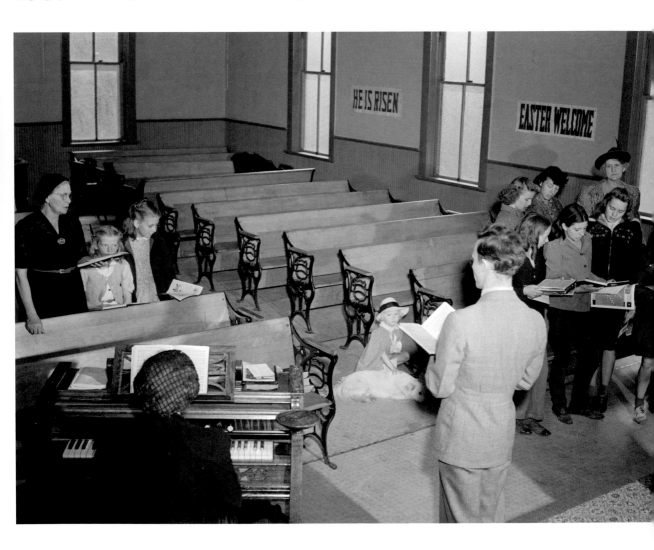

Wisdom, Montana, April 1942.

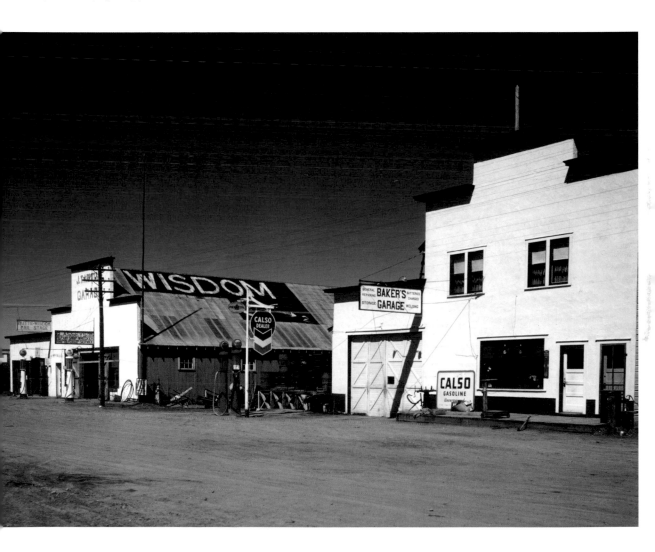

43

Loading a truck bound for Mobile at the Associated Transport Company, New Orleans, Louisiana, March 1943.

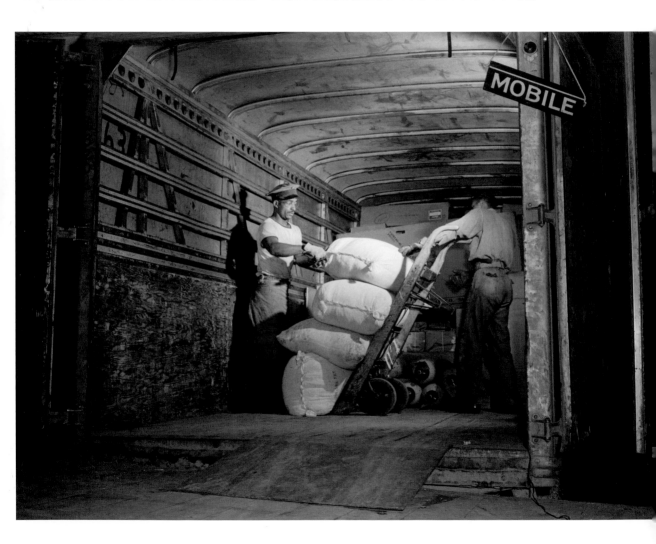

Grain elevator, Amarillo, Texas, November 1942.

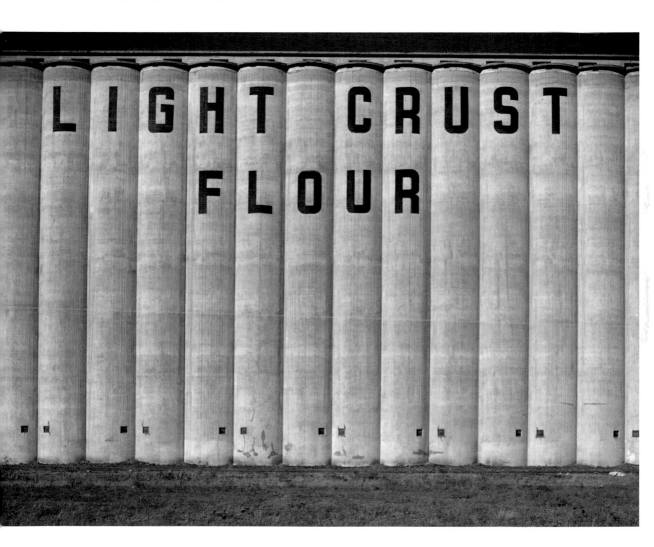

A Valley State Employment Service sign in a shop window, Harrisonburg, Shenandoah Valley, May 1941.

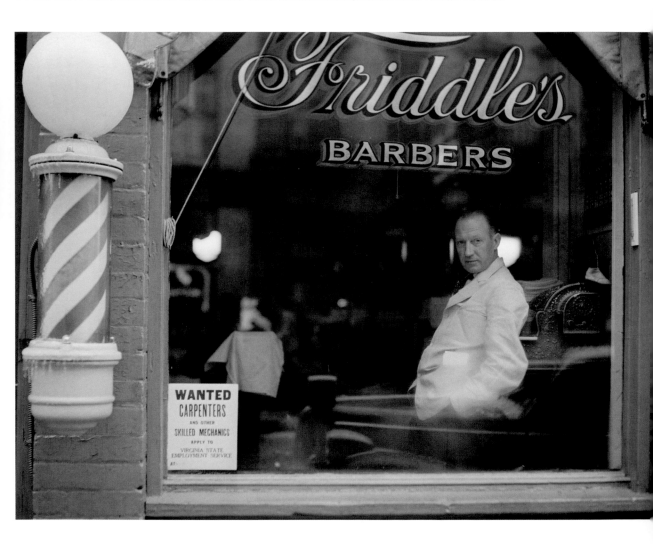

Sign in a beer parlor window, Sisseton, South Dakota, September 1939.

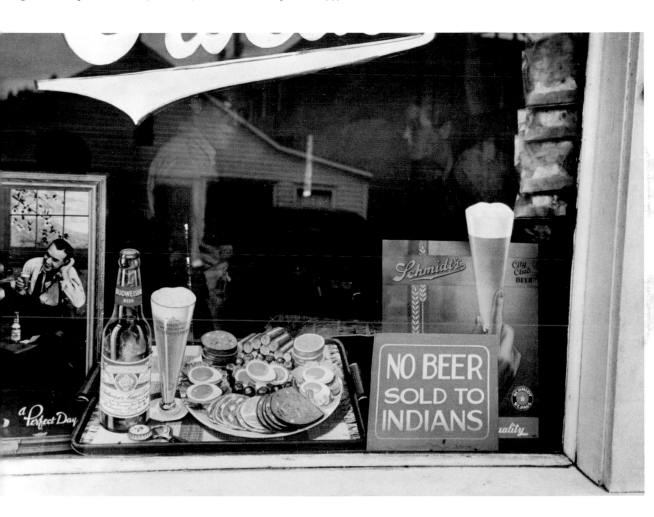

Cars parked diagonally along parking meters, Omaha, Nebraska, November 1938.

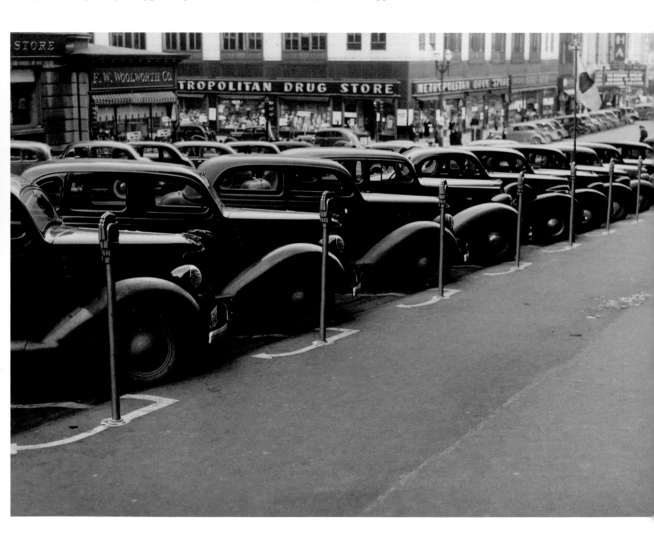

Group of trailers at a Farm Security Administration camp, Erie, Pennsylvania, June 1941.

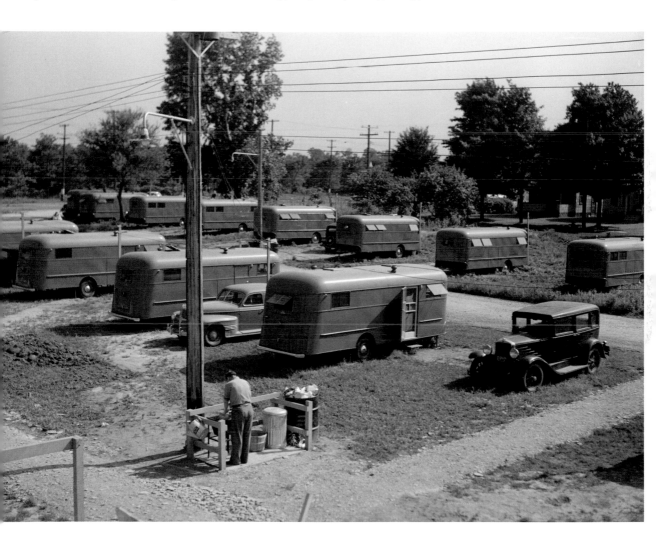

49

Worker at a carbon black plant, Sunray, Texas, 1942.

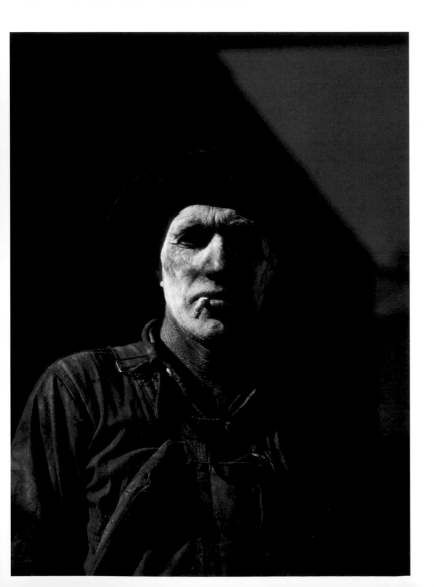

50

Town policeman, Litchfield, Minnesota, September 1939.

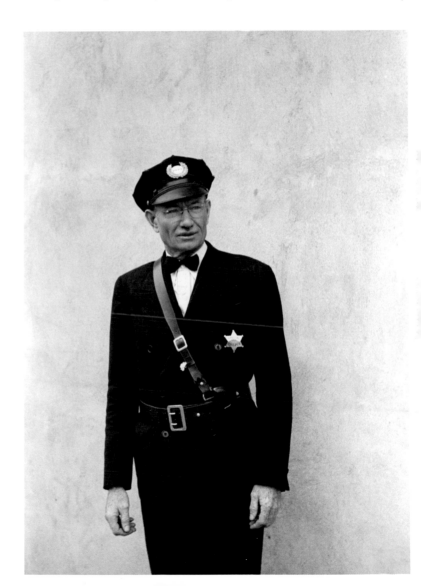

Images

The images in the Farm Security Administration–Office of War Information (FSA–OWI) Photograph Collection form an extensive pictorial record of American life between 1935 and 1944. In total, the collection consists of about 171,000 black-and-white film negatives and transparencies, 1,610 color transparencies, and around 107,000 black-and-white photographic prints, most of which were made from the negatives and transparencies.

All images are from the Library of Congress, Prints and Photographs Division. The reproduction numbers noted below correspond to the page on which the image appears. Each number bears the prefix LC-DIG-fsa (e.g., LC-DIG-fsa-8a16183). The entire number should be cited when ordering reproductions. To order, direct your request to: The Library of Congress, Photoduplication Service, Washington, D.C. 20450-4570, tel. 202-707-5640. Alternatively, digitized image files may be downloaded from the Prints and Photographs website at http://www.loc.gov/rr/print/catalog.html.